Copyright (c) 2016
L. Stacey
All rights reserved

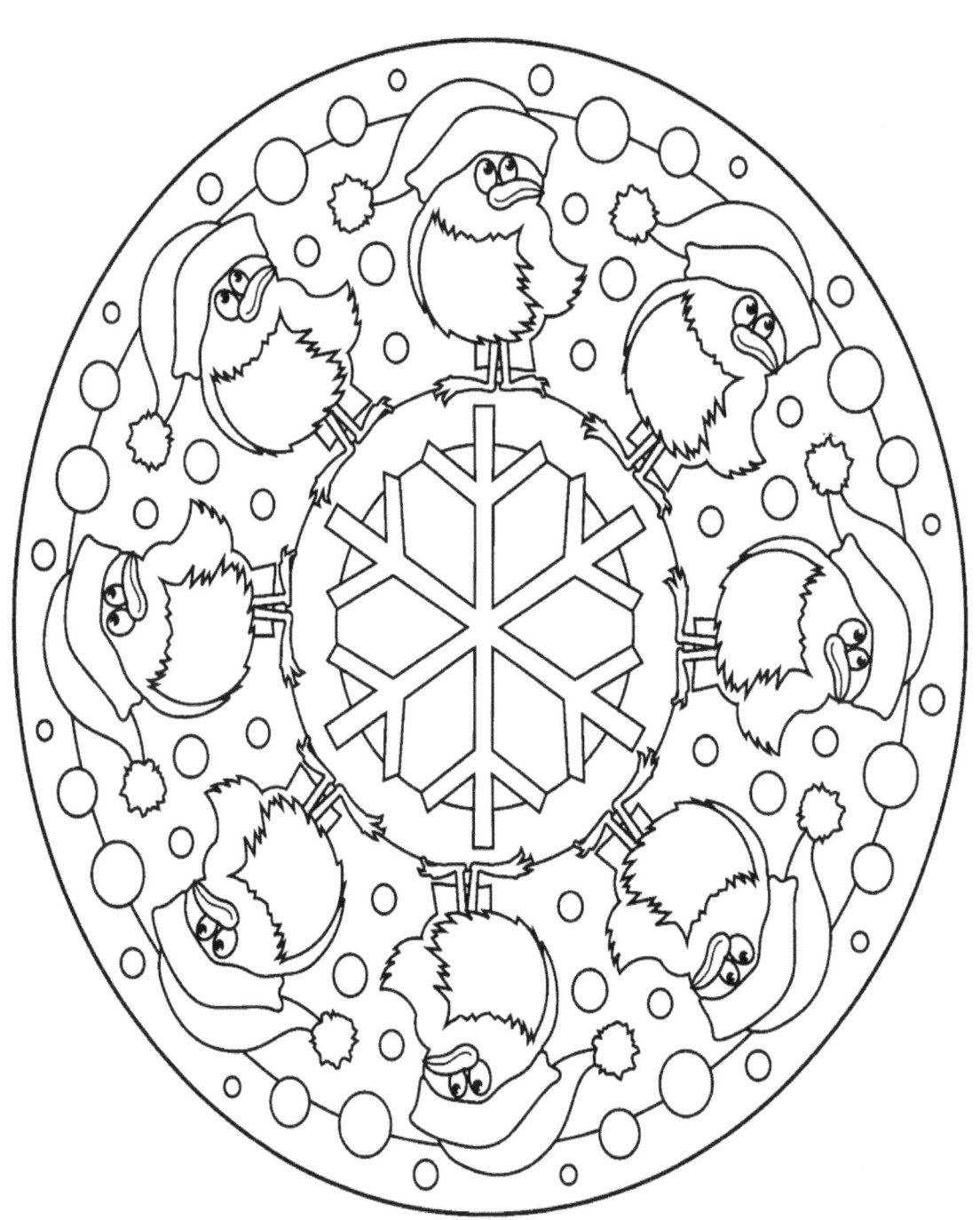

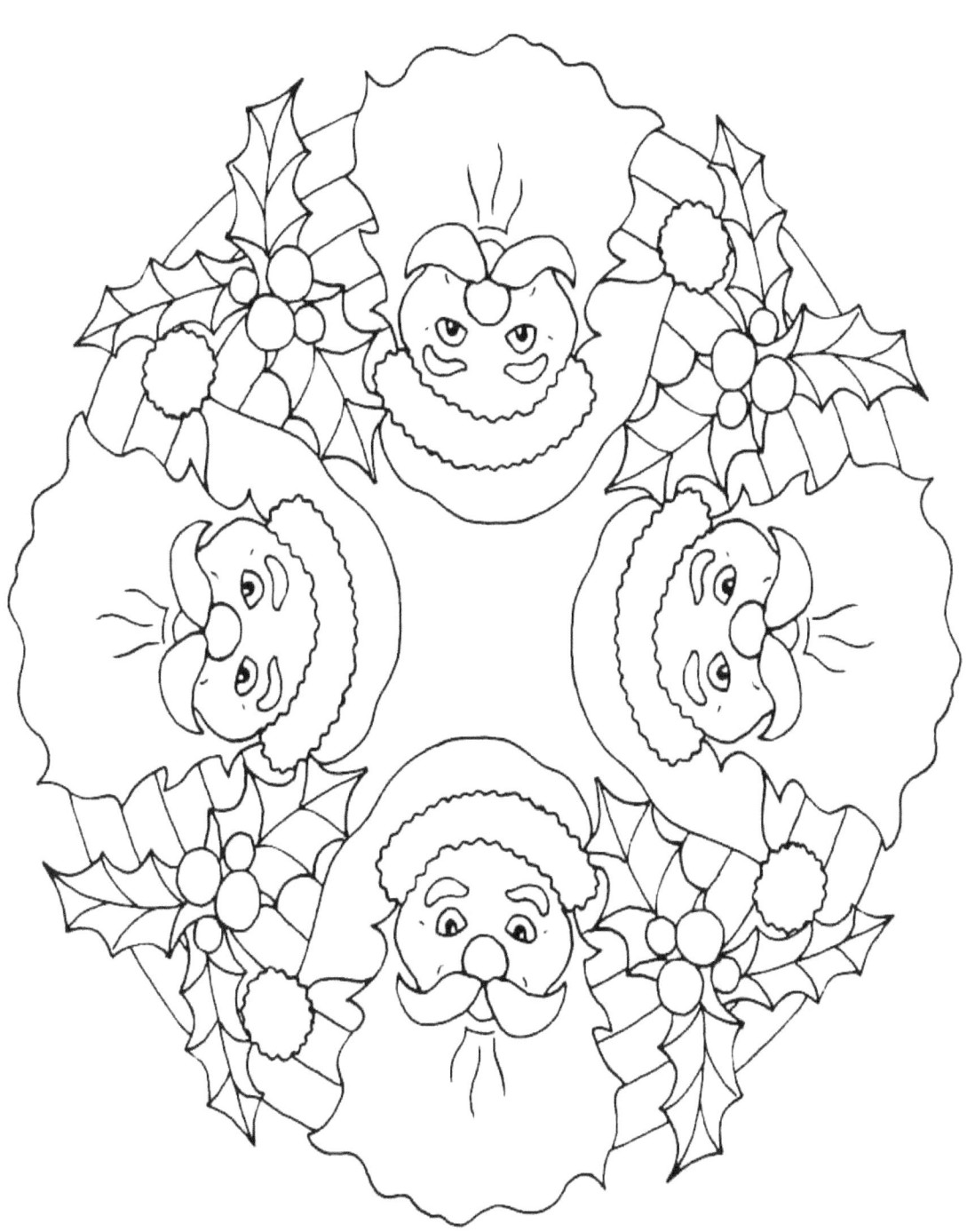

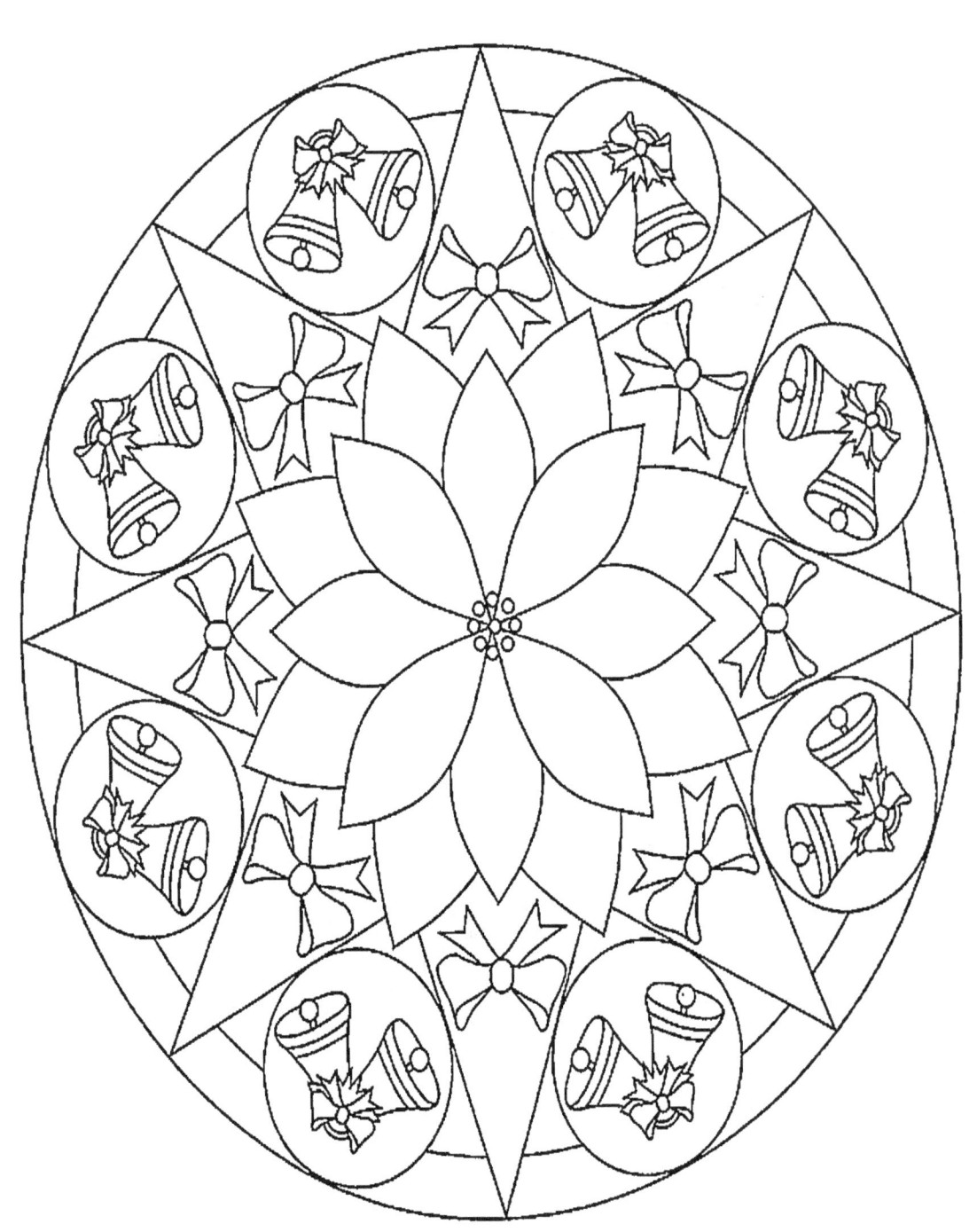

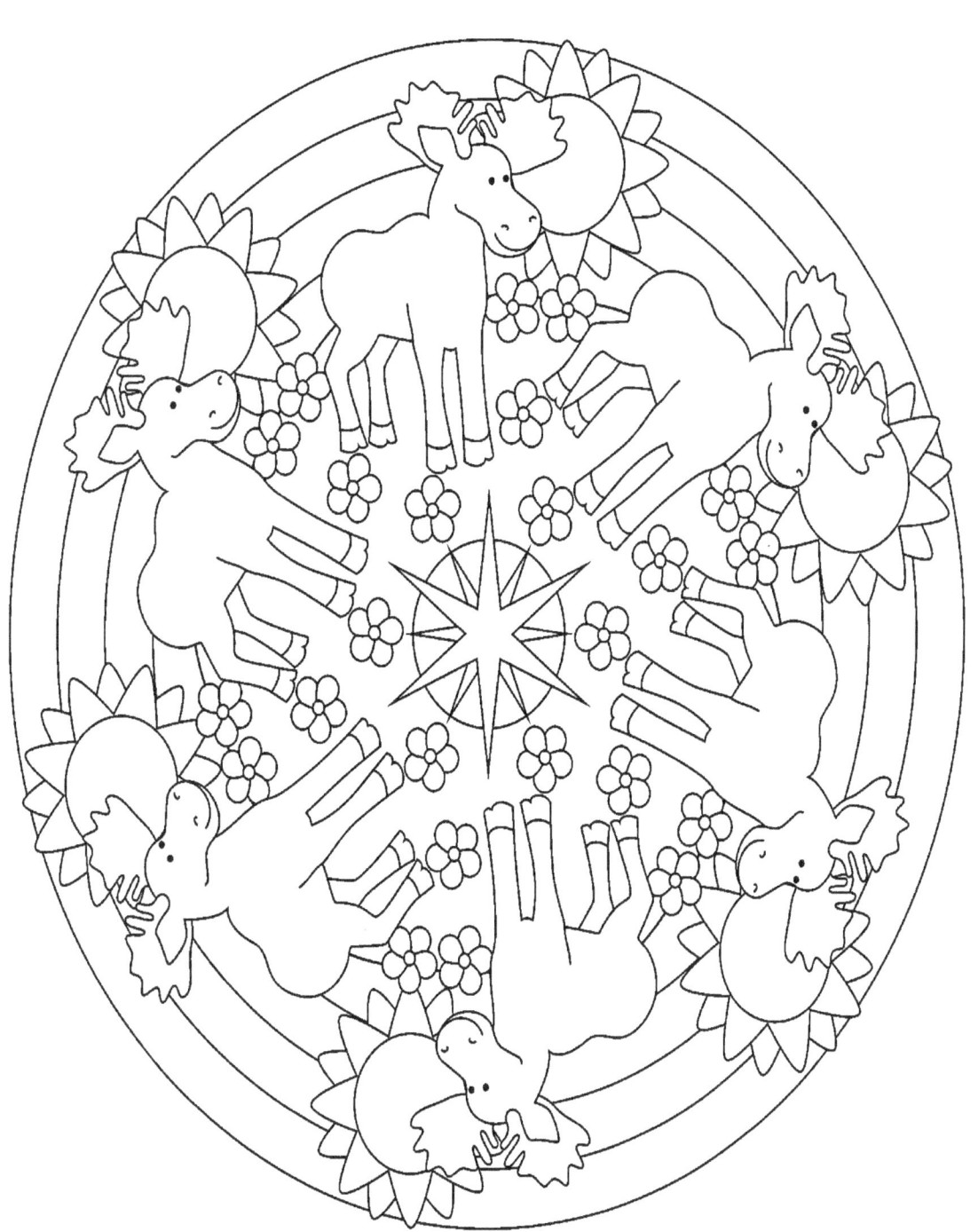

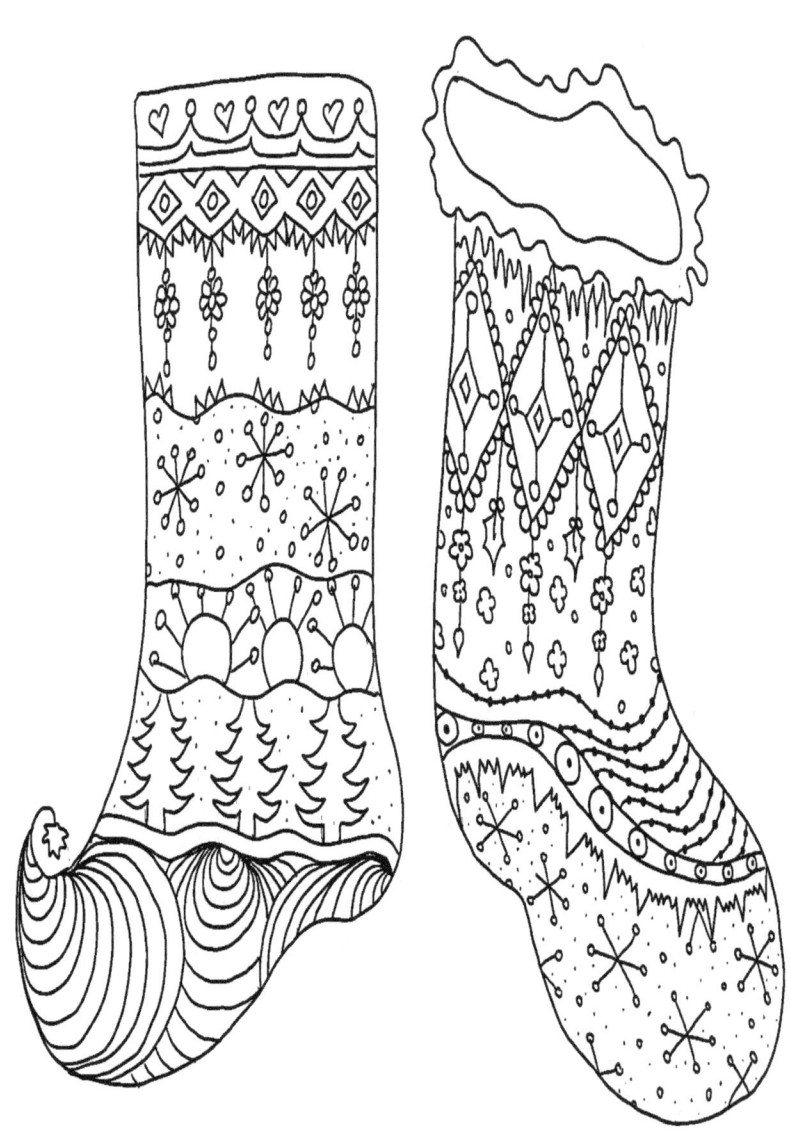

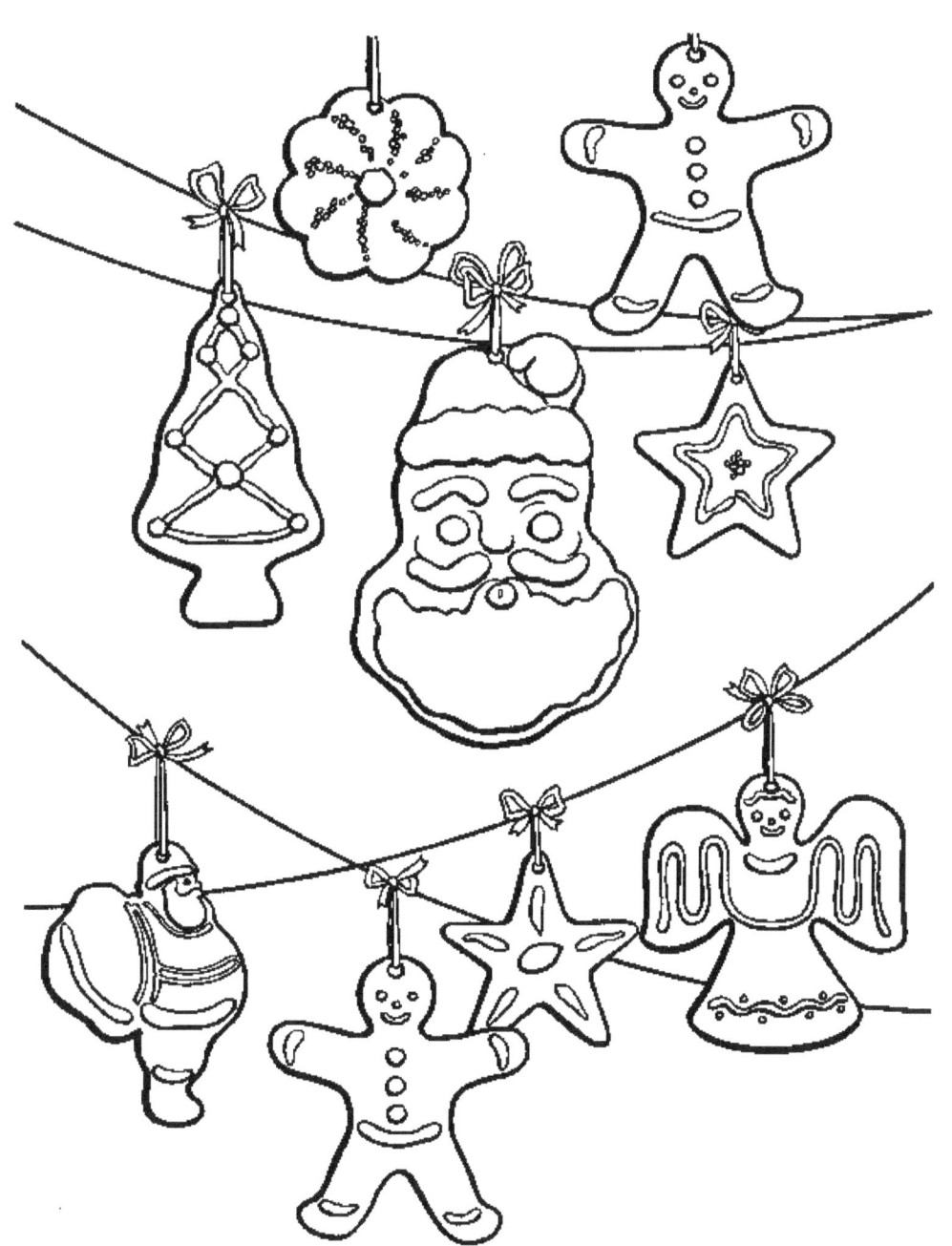

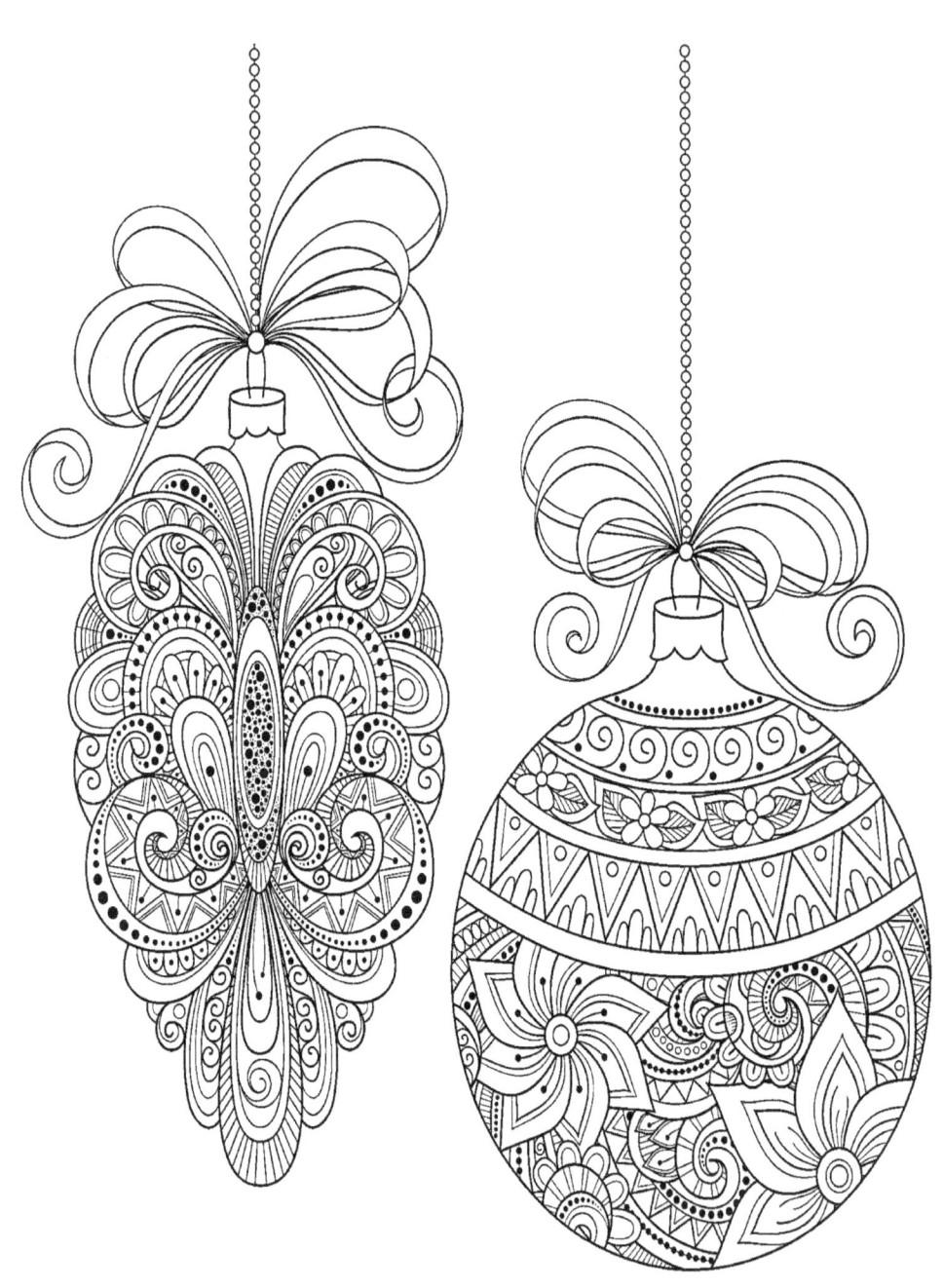

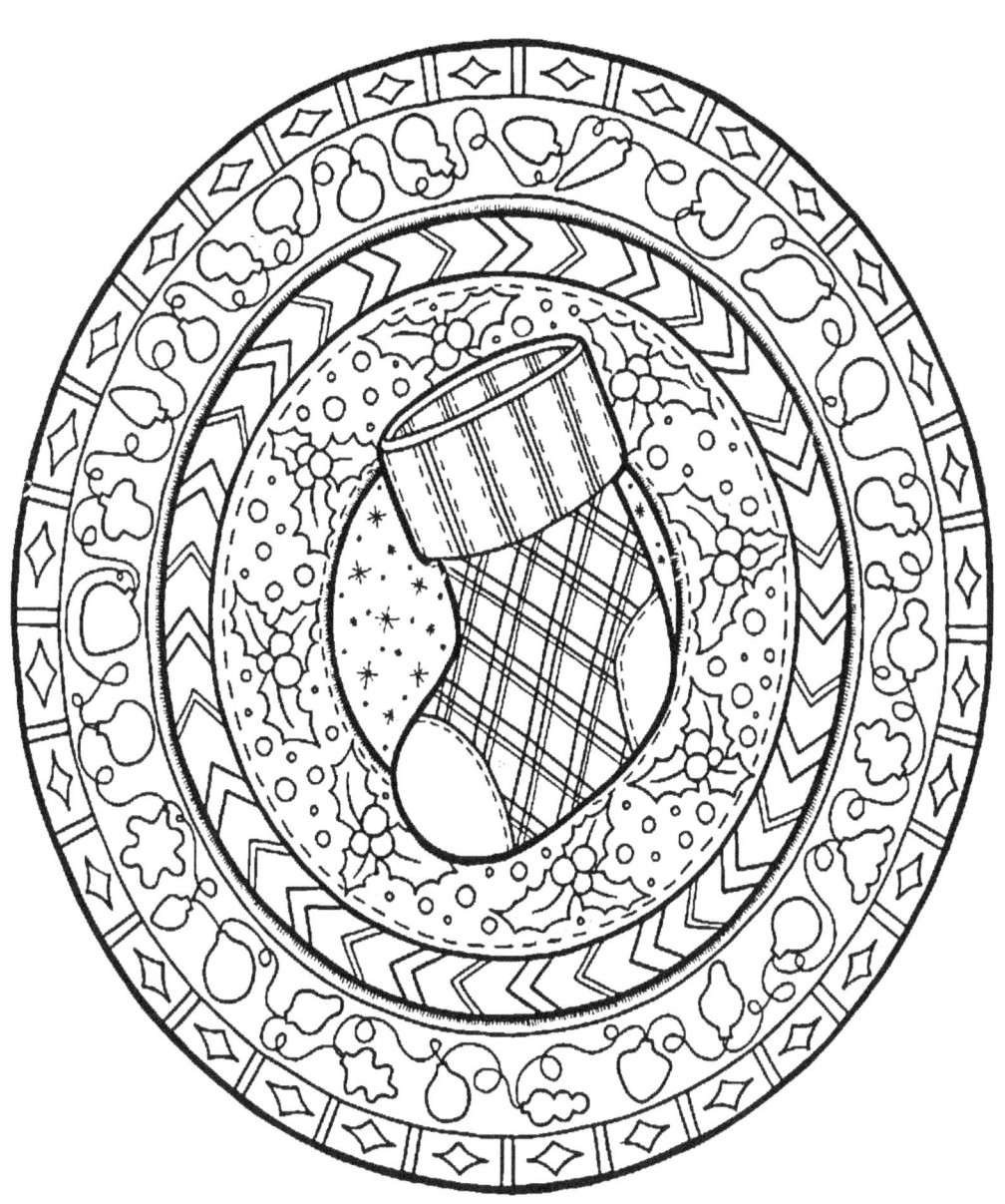

www.ingramcontent.com/pod-product-compliance
Lightning Source LLC
Chambersburg PA
CBHW080529190526
45169CB00008B/3102